Essentials of
LANDSCAPE
COMPOSITION

LEONARD RICHMOND

Dover Publications, Inc.
Mineola, New York

Bibliographical Note

This Dover edition, first published in 2008, is an unabridged republication of *Essentials of Pictorial Design,* originally published by Sir Isaac Pitman & Sons, Ltd., London, in 1933.

Library of Congress Cataloging-in-Publication Data

Richmond, Leonard.
 [Essentials of pictorial design]
 Essentials of landscape composition / Leonard Richmond.
 p. cm.
 Originally published: Essentials of pictorial design. London : I. Pitman, 1933.
 ISBN-13: 978-0-486-46911-9 (pbk.)
 ISBN-10: 0-486-46911-5 (pbk.)
 1. Compostion (Art) 2. Drawing—Technique. I. Title.

NC740.R5 2008
701'.8—dc22

 2008026458

Manufactured in the United States of America
Dover Publications, Inc., 31 East 2nd Street, Mineola, N.Y. 11501

PREFACE

THOSE who are interested in art will find that this book has a definite purpose, namely, to stimulate a desire for pictorial invention. To achieve success in this direction it is necessary to acquire a clear understanding—through analytical lines and masses—of the basic designs on which certain pictures have been planned, developed, and completed.

There are no limits to pictorial invention. The pleasure of making creative designs produces a feeling of personal pride, and being the expression of self it generally satisfies the egoism of the one who creates.

Most people are gifted with artistic impulse either in one direction or in another. Conversely, most people have not acquired enough technique in drawing to be able to give visible expression to their artistic impulses.

The novice, when making his first attempts at drawing, usually selects (mostly without conscious thought) a lead pencil—generally hard lead—and vainly tries to make an intelligent statement in drawing. Meeting with failures, he is liable to grip the pencil with some intensity, thereby making it quite impossible to draw at all, since the pencil must be held loosely to render correct lines and curves.

The many pleasant preparatory exercises in this book entirely ignore the use of a lead pencil, and rely only on the brush (with the exception of four pen drawings) for depicting the brown tinted outlines. When a sable brush is used on smooth paper the coloured ink glides without effort over the surface and, consequently, is more likely to obey the artistic mind of the manipulator, whereas a lead pencil demands a higher standard of mechanical accuracy than is usually possessed by the beginner. Thus its use would not only prove a disheartening experience, but would also put a check on

pictorial invention. For beginners more drawing can be learnt in a month with a smooth running sable paint brush than in twelve months with a lead pencil. For fear of being misunderstood, let me state clearly that after the necessary experience has been acquired by training the eye and hand to work well together, a lead pencil can—and does—express genuine beauty in artistic achievement. Suffice it to say that the preliminary use of the paint brush for pictorial invention should take the student along the "*short road to success.*"

The majority of educational books written on art help only those who have already made considerable advance in art study. This book is planned on a much wider basis. Assuming correctly that writing is drawing, and that the technique of writing is mastered by practically every individual, there does not appear to be any reason why—if they so desire it—they should not be able to draw as easily as they write.

There is no doubt that creative drawing not only makes the mind active and observant, but also rapidly improves the technique itself.

When correct drawing in outline is achieved it proves conclusively that the artist has not only attained the power to make the drawing, but has also mastered the knowledge of form—or solid substance—which is enclosed in the space or area between the various arrangements of outline.

The simple examples in Fig. 1 illustrate the affinity between form and line. They are, of course, only a few preliminary demonstrations relating to form and line, but the principle is the same for all visible subjects as seen in nature and elsewhere. In every appropriate example shown in this volume, the solid mass forms in the finished picture should be studied, in order to gain a more complete understanding of the different stages suggested in outline.

 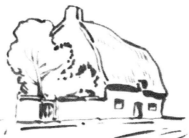

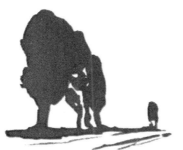

FIG. 1

CONTENTS

CHAPTER I

SIMPLE LINES AND CURVES

VERY few artists' materials are necessary for the numerous examples in this book. All that is required is paper, a bottle of vandyke brown waterproof ink, four paint brushes, and a bottle of water.

For the paper a light buff or yellowish tinted writing-pad,

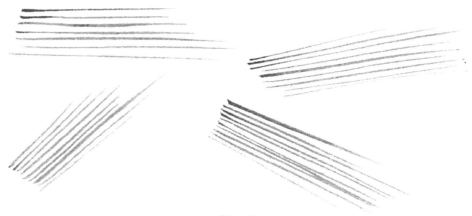

FIG. 2

priced at one shilling, is sufficient. The vandyke brown waterproof ink is about the same price, whilst the four small sable brushes should be numbers 0, 1, 2, and 3. A bottle of pure water is essential, as the water-colour brushes occasionally need cleansing during the making of a picture, and always require a thorough wash before being put away for future

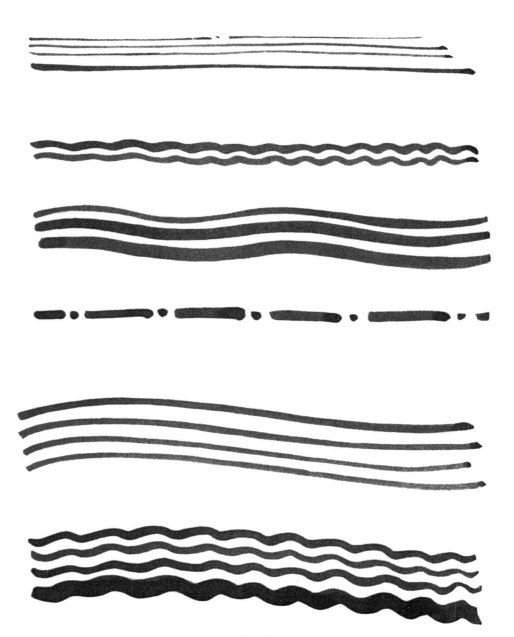

FIG. 3

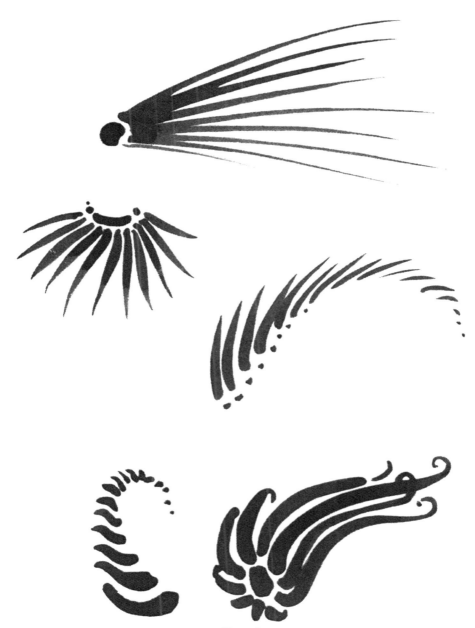

FIG. 4

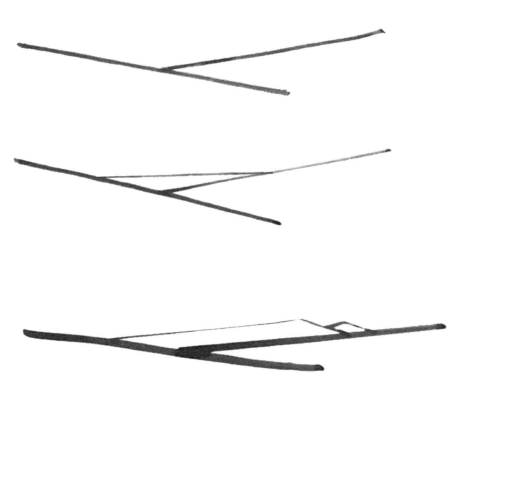

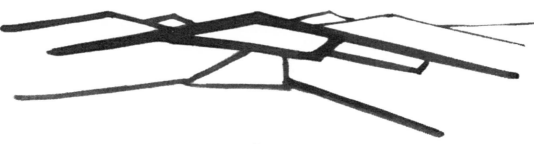

FIG. 5

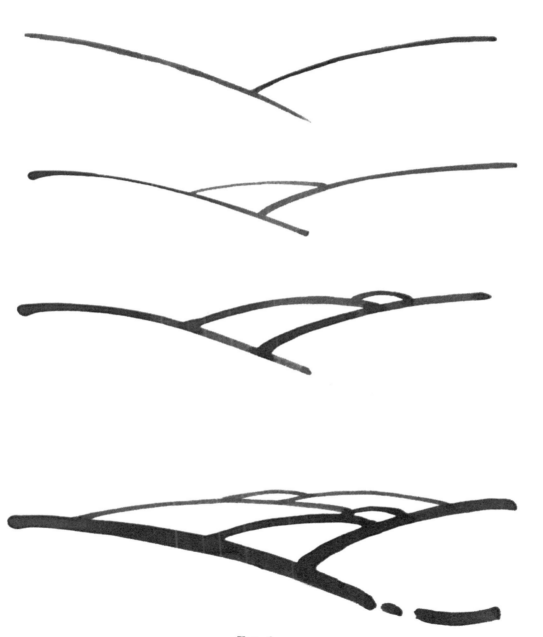

FIG. 6

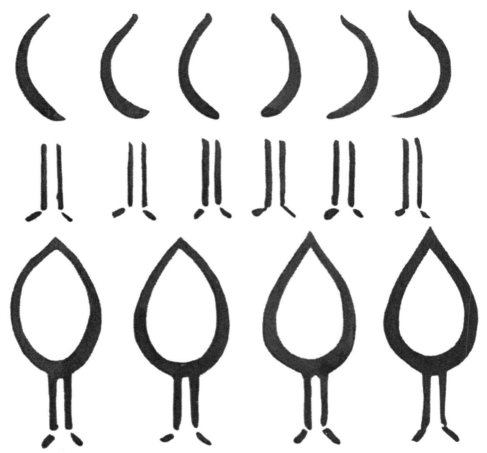

FIG. 7

use. The slightest suggestion of any gritty material in the brush will prevent it from working smoothly.

The line examples in Fig. 2 should be practised without making any attempt at drawing. Use a No. 2 sable brush, and let it move very easily and swiftly along the smooth surfaced

paper. A series of quickly executed lines somewhat parallel in direction is admirable practice for the beginner. Take the brush rapidly off the paper when nearing the end of a line or curve. It helps to give a decisive finish, whereas if it is taken slowly off the paper the result will be a heavy finish.

It is surprising how many expressive forms can be made with horizontal lines and curves as shown in Fig. 3; similar variations can be obtained with lines sloping vertically or at different angles.

The same easy method of brush drawing should be used for this example as before, and experiments tried to achieve different types of lines and curves.

The next demonstration consists of curves which radiate from a given point as depicted in Fig. 4. Here again rapidity in handling is of great importance. Mistakes do not matter at first. Confidence will soon come if there is no struggling to achieve perfection.

Next try a series of intersecting lines as seen in Fig. 5, once more allowing the brush to move at ease, and letting the drawing take care of itself.

When practising vary the thickness of your lines.

Now draw similar shapes, using curves only (see Fig. 6).

Thoroughly master Figs. 5 and 6, and then become acquainted with the demonstrations in Fig. 7 by practising in the first instance the six inverted curves and the straight lines as seen in the first and second row, and finally fitting together the elements above, so as to complete the study as depicted in the four examples at the foot.

Memorize all the elements of brush drawing in this chapter so that no further reference will be necessary.

CHAPTER II

ELEMENTARY SPACE FILLING

IF the precaution has been taken of thoroughly practising all the demonstrations in Chapter I, no difficulty will be found in handling the various examples of simple space filling set out in Chapter II.

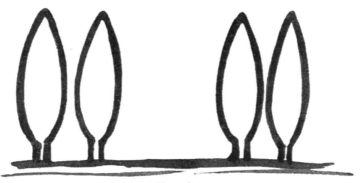

FIG. 8

It is advisable to work on a fairly large scale, as small drawings are not only difficult to manage but are apt to cripple a sense of freedom or fluency in brush handling.

The rectangle marked *A* in Plate I shows two intersecting curves. (See also Fig. 6 in Chapter I.) In example *B* the same two curves are shown with two smaller but similar curves placed on top of the first-named curves.

Example *C*, like *B*, is reinforced with another pair of intersecting curves. *D* has also received the same treatment. The two pictorial looking demonstrations, *E* and *F*, are

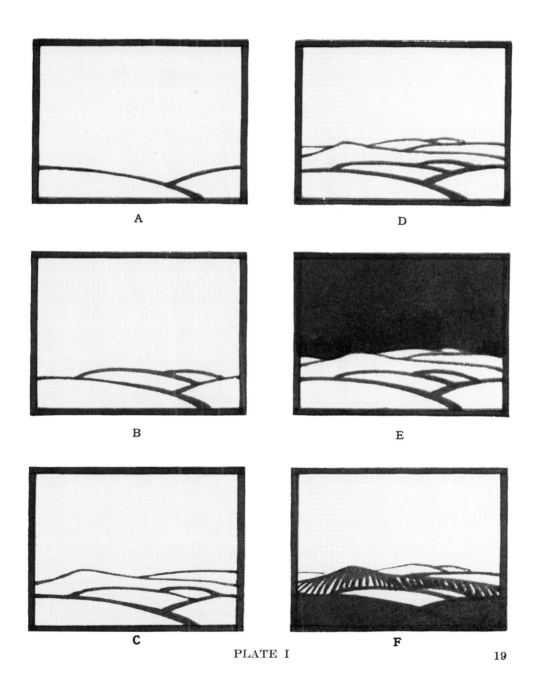

A

B

C

D

E

F

PLATE I

most instructive, as the drawing of each is exactly the same as *D*.

It is astonishing how two drawings which are precise replicas of each other can be made so different in appearance. The flat dark tone in *E* gives solidity to the space occupied by the intersecting curves in front. In *F* the flat shadow in the lower part of the drawing, supported by the parallel line

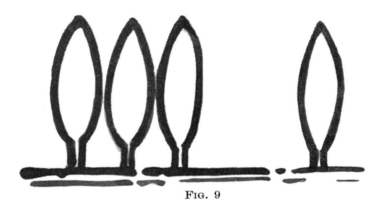

Fig. 9

treatment, presents a totally different aspect to the example immediately above.

In the six drawings in Plate II the same arrangement of curves as seen in Plate I was used, but placed in the top portion of each rectangle instead of the lower end as before. A similar formula was also adopted of additional curves, whilst the same scheme of flat tones was used in *E* and *F*.

The three drawings in Plate III, *A*, *B* and *C*, should be very easy to copy after mastering the demonstrations shown in Fig. 7. Notice that they are so arranged that two forms are placed on the left side and only one on the right, thus giving some piquancy to a pattern which would look rather dull with two similar shapes on either side, as seen in Fig. 8.

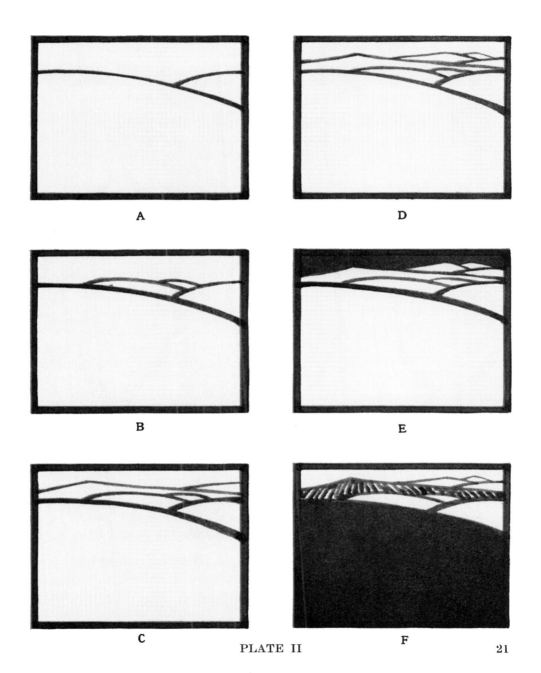

A

D

B

E

C

F

PLATE II

Fig. 9 also contains four upright shapes, but one is taken away from the right, and placed on the left side, thus giving an agreeable feeling of interesting proportion.

The other three examples, *D*, *E* and *F* on Plate III, are arranged in prec sely the same manner as the first three on

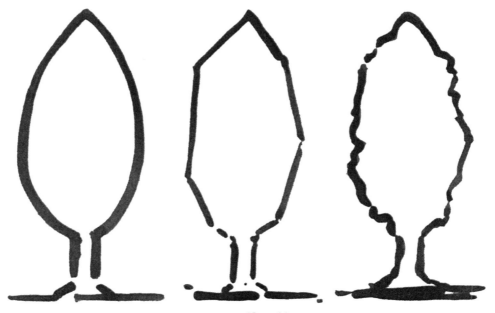

FIG. 10

the left side, but the upright elliptical curves are treated in a much more interesting way by varying the contours of the outlines, which now give a suggestion of tree formation.

The evolution of elliptical shapes gradating to natural tree formation is shown in Fig. 10.

Do not try to copy the demonstration examples exactly as depicted in this book. The spirit of the subject is far more important than a slavish imitation. Enjoy liberty in

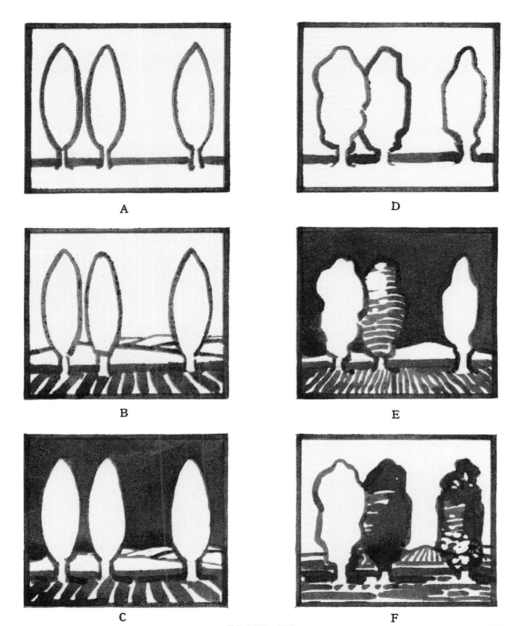

A

D

B

E

C

F

PLATE III

drawing, and never "struggle" when endeavouring to achieve something.

The first three plates are of extreme importance, and should be committed to memory. The elementary principles of composition or pattern designing, in addition to the necessary knowledge of proportion such as two versus one, or

FIG. 11 FIG. 12

three versus one, are all clearly indicated in Plates III and IV, as well as Fig. 9. After breaking away on Plate III from the upright elliptical forms we should now have far more freedom in drawing. The large trees depicted in Plate IV convey some feeling of aesthetic pleasure, since they are no longer arranged in exact vertical formation.

The elements of light, shadow, and tone are noticeable in some of the examples in Plates III and IV. A simple tree in outline, with a correspondingly simple tree painted flat and

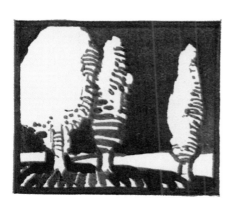

PLATE IV 25

placed immediately behind it, affords a striking contrast of
light versus shadow. If a tree in light has two dark trees in
shadow, one on either side, the central tree, although only
drawn in outline, assumes a solid appearance, which is
entirely lacking when it is isolated from a dark background.

Fig. 11 represents a tree in simple outline, whilst in Fig. 12

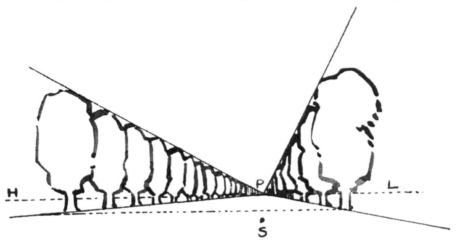

FIG. 13

a similar tree is shown supported by two dark trees on each
side.

Hitherto trees in the foreground only have been dealt with.
It is advisable at this stage to deal with trees that recede in
the picture. The four examples on Plate V show an approx-
imate perspective of trees converging from the foreground to
the distance. In examples *A* and *C* the lines *ab* and *cd* repre-
sent the horizontal line or the height of the eye above the
ground. The other dotted converging lines help to suggest
the perspective heights of the receding trees. The old rule
that receding horizontal lines above the eye go in a

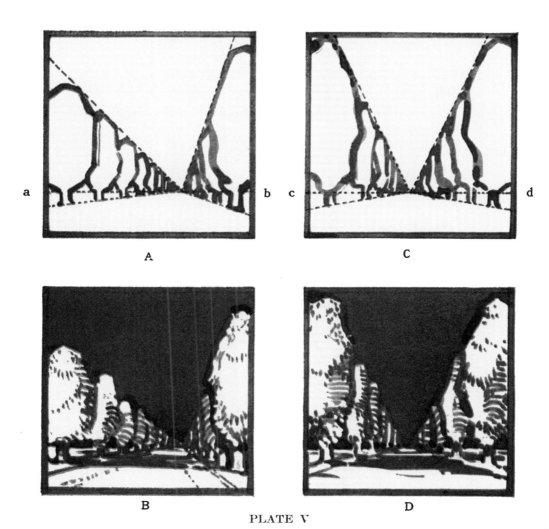

a b c d

A C

B D

PLATE V

27

downward direction, whilst receding horizontal lines below the eye level appear to converge upwards, can be plainly seen in *A*, *B*, *C* and *D*.

The two finished pictures, *B* and *D*, are treated in a naturalistic manner with light and shadow on the trees and foreground, both of which are strengthened by the support of the dark sky beyond.

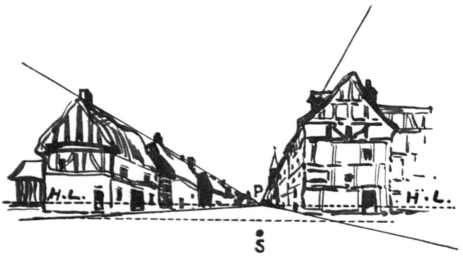

Fig. 14

In Fig. 13 the perspective problem of trees is made clearer by denoting the position of the spectator at the spot marked *S*. The horizontal line or height of the eye above the ground is marked *H–L*. *P* is the vanishing point where the various receding lines meet on the horizontal line.

Precisely the same remarks apply to the street scene subject in Fig. 14. Once again *S* denotes the position of the spectator. All the buildings on the left side are approximately the same height, so as to simplify the problem

CHAPTER III

BEFORE attempting to draw any of the examples on Plates VI and VII, the simple forms in Fig. 15 should be carefully studied and memorized.

It will be found very easy to copy the shape marked *A*.

B is only a repetition of *A*.

C is similar to *B*, but the horizontal line is replaced by a curved line.

Avoid the incorrect rendering of *D*—remember the material resting on the curved line should be at right angles to it.

Let a little daylight into the lower part of each solid mass as seen in *E*.

These few demonstrations are invaluable as a foundation for future progress. On looking at Plates VI and VII, it can be quickly seen how ingenious these simple forms appear when placed in a landscape, and assume also the characteristic formation of trees, grouped in the distance. The principle of intersecting curves, demonstrated in Plates I and II, is again used, but in more pictorial surroundings. The series of converging lines in the foreground of the four lower pictures make a lively surface as well as an interesting contrast to the sky and middle distance.

Figs. 16 and 17 show the compositional arrangement of horizontal lines and curves, depicting the simple basis on which the various trees, fields, and distant scenery in Fig. 18 was planned.

Fig. 19 displays some groups of trees spaced at varying distances in the landscape.

Like many of the previous demonstrations, it is advisable to memorize these four examples since they represent an

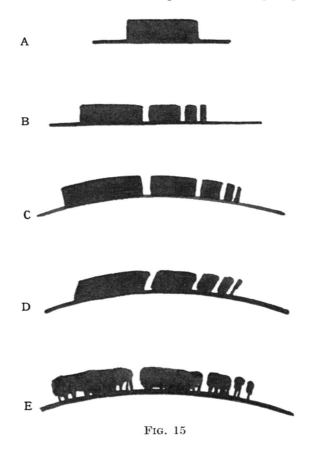

FIG. 15

important feature in pictorial designing. On referring to Plate VIII the truth of this statement is obvious. *A*, *B*, and *C* are based solely on Figs. 16, 17, and 18, whilst *D*, *E*, and

FIG. 16

FIG. 17

FIG. 18

FIG. 19

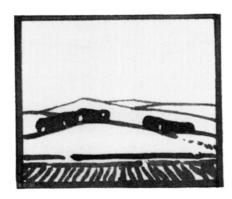 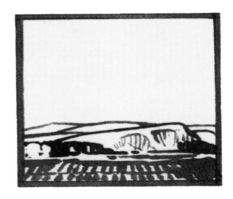

32 PLATE VI

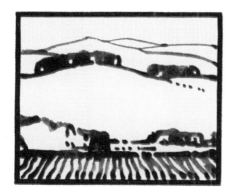
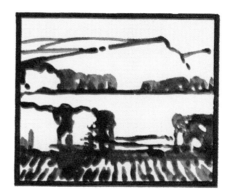
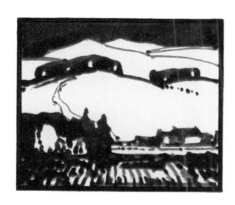
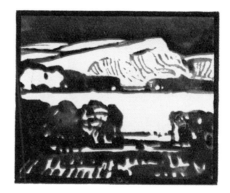

PLATE VII

33

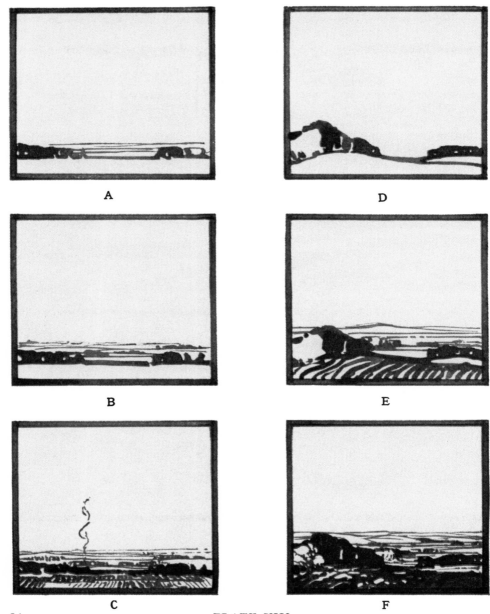

A

D

B

E

C

F

PLATE VIII

PLATE IX

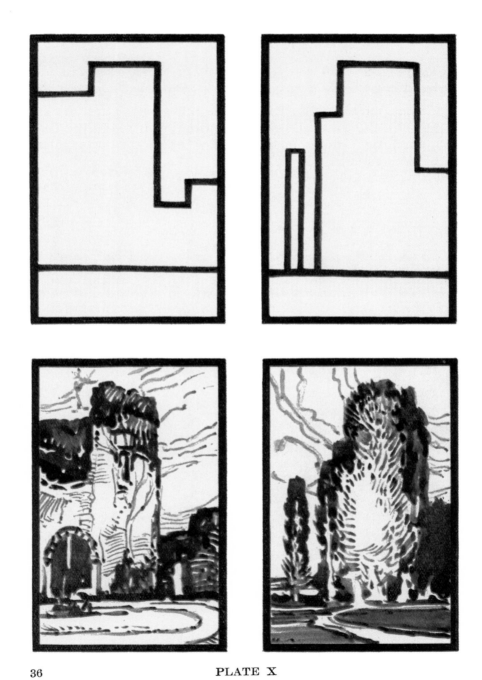

PLATE X

F are each planned on the same constructional lines as Fig. 19.

Four arbitrary designs of space filling, drawn on Plates IX and X, are each planned with rigid severity. The naturalistic pictures depicted below retain the rectangular formation above.

It is a fascinating pastime to evolve pictures from what might appear at first glance to be unsympathetic material. The drastic formation of lines at right angles leave no loopholes for weak compositions, yet charm can be introduced by using some of the more tender aspects in nature—without in any way losing the original conception.

Since trees have now become a feature in some of the foregoing landscapes it would be profitable to study Figs. 24 to 28 in Chapter VIII.

CHAPTER IV

ELLIPTICAL FORMS

DIFFERENT shaped curves in a picture, provided they are designed so as to convey harmonious relations to each other, inevitably produce pleasing compositions in landscape drawings and paintings. The movement in the clouds depicted on Plate XI owes its origin entirely to a foundation of

FIG. 20

elliptical—or tangential curves—that can be clearly seen in the two top examples.

Most of the illustrated plates in this book are drawn in progressive stages, so as to enable the student to appreciate the underlying composition of a picture.

Considerable portions of the Sussex Downs in England are based on the suavity and charm of harmonious curves. Pastoral scenery, or undulating country, bears witness to a pleasant elliptical foundation.

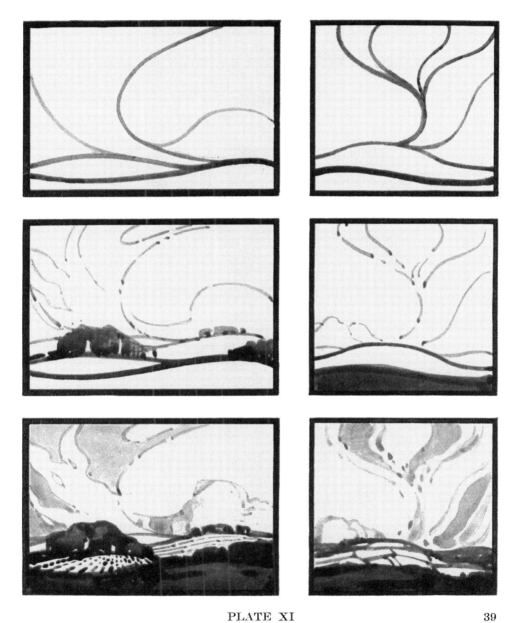

PLATE XI

Fig. 21

Fig. 22

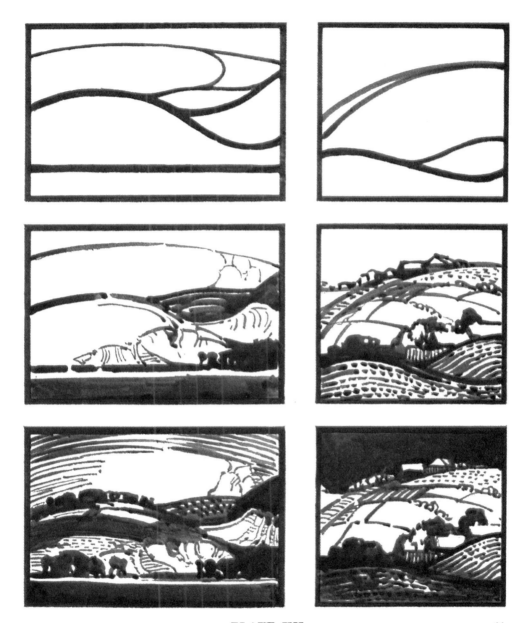

PLATE XII 41

Fig. 20 shows the effect of a lengthy group of trees situated on undulating ground which—together with the trees—recedes towards the distance. Since the laws of perspective demand that nearer objects appear larger than similar objects in the distance, so, in this group of trees, the nearer ones are taller than the more distant examples.

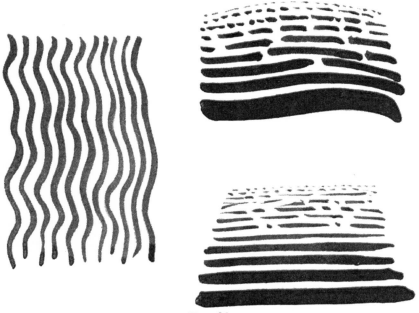

FIG. 23

The geometric arrangement of circular curves in Fig. 21 should be carefully copied so as to comprehend its ordered arrangement before proceeding to the more enjoyable task of drawing the groups of trees shown in Fig. 22. In this sketch particular attention should be given to the top portion of the foreground trees receding towards the middle distance. Although naturalistically drawn and loosely handled they still retain the same formation as the geometric demonstration.

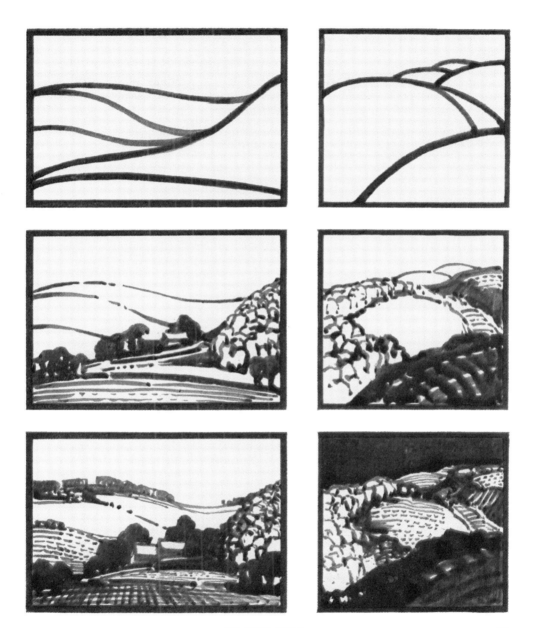

PLATE XIII

When sketching similar subjects out of doors the inexperienced artist—unless some previous information has been obtained—is liable to suffer through lack of competent knowledge on the handling of woodland scenes.

Three demonstrations of parallel lines, curves, and dots are shown in Fig. 23. Considerable variety can be achieved by this method in brush technique. Again—as in previous examples—mastery must be obtained before adopting a similar treatment as shown in the finished landscape designs on Plates XI, XII, and XIII.

Students who go to the trouble of copying these three plates would be well repaid by using precisely the same elliptical formula as depicted on the top line of each plate, and then invent a landscape more in keeping with their own creative impulse. This book is written solely for the purpose of arresting students' attention to original ideas in composition. It is a guide for that purpose, with the devout hope that the guide is only a stepping stone to greater things for the young explorer.

It is surprising the number of decorative examples that can be evolved from elliptical formations only. The finished pictures in this chapter suggest certain poster qualities that could be made quite telling in colour on the hoardings.

CHAPTER V

CLOUDS can be controlled and organized so as to make a
design in a picture, equally as well as the floral details of
a curtain hanging, or the incidental decoration of a carpet.
Aimless sketches, therefore, of clouds, with no coherent inten-
tions as to their proper setting in a landscape, is a tiresome
waste of time.

The two simple studies on Plate XIV were drawn so as to
show that some definite planning is required even though only
a few clouds are involved. The three gradated stages on the
left side require little analysis. The little clouds at the foot of
the sky balance the effect of the large circular group placed
in the top left corner.

The three examples on the right give an illustration showing
how the sky is evenly distributed by the sweeping curve of
clouds, commencing from the horizon, and spreading upwards
towards the left side.

The four stages of Plate XV suggest an easy way of subduing
the bright effect of clouds by washing a fairly flat tone over the
whole of the sky and clouds in the final stage. The shape of
the clouds are still noticeable in the finished picture, despite
the flat wash. The dark background helps to accentuate the
light on the rock quarry and foreground material.

Plate XVI demonstrates the method for building up a
cloud composition, the result of which is seen in the finished
landscape of thin layers of clouds, radiating outwards to the
right and left respectively.

In Plate XVII the clouds were drawn with a clear and

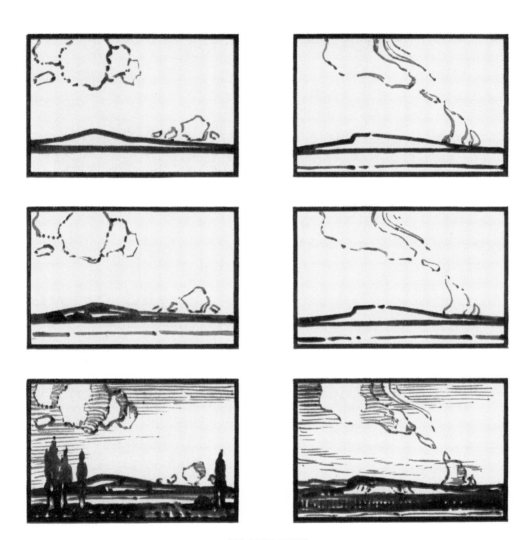

PLATE XIV

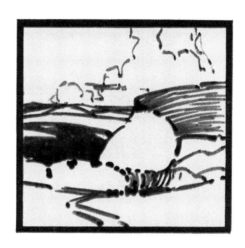

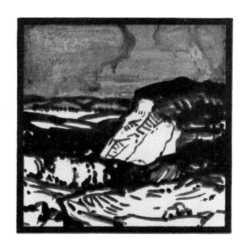

PLATE XV

47

PLATE XVI

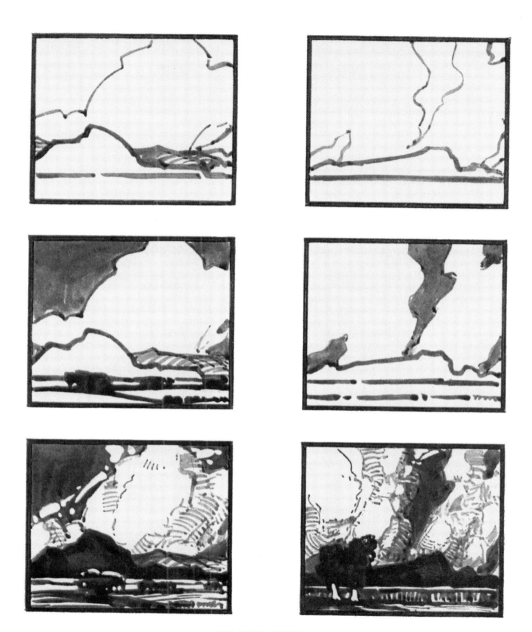

PLATE XVII

49

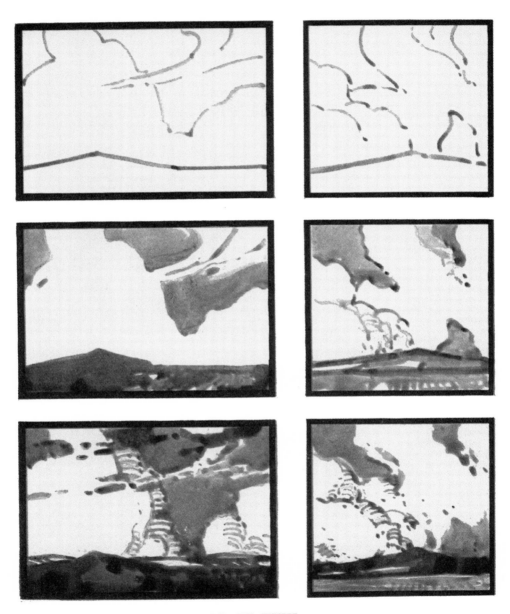

PLATE XVIII

somewhat hard definition, done more for the purpose of acquiring knowledge than for a display of artistic handling. It is a welcome change to paint in the looser style of **Plate XVIII,** using plenty of water with the brown ink so that the brush could function with a luscious water-colour effect.

CHAPTER VI

OLD CASTLES AND COTTAGES

THERE are many varying styles of architectural buildings one would like to include in this chapter, but for the sake of expediency three examples are selected of ancient castles or ruins, and one of country cottages.

The light and shadow on Plate **XIX** are so arranged that the silhouette form of the castle—although cut into by the glancing angle of light on the tower and walls—is still definite enough to show its general formation. The more or less parallel lines drawn on the distant part of the picture help to give some contrast to the solid masonry in the foreground.

Plates **XX** and **XXI** are each represented in two stages so that the original line work can be studied before discovering the secrets of shadow spacing. The disposition—or arrangement—of large masses of shadow is very important. Shadows can make or mar a subject. In this instance they were used to accentuate the antiquity of the subject, as well as the feeling of crumbling material.

Cottages with their attendant out-buildings have long been a source of pleasure to artists—especially amateur artists. There are some cottages, of course, which are just pretty and nothing else. They should be avoided in a picture, or else, if necessary for the subject, drawn with more distinction than is generally displayed in the original scene. An attempt in Plate **XXII** was made to avoid a commonplace rendering of cottages. As regards windows, if they are on the large side, it is a wise policy to keep them light in tone, otherwise they

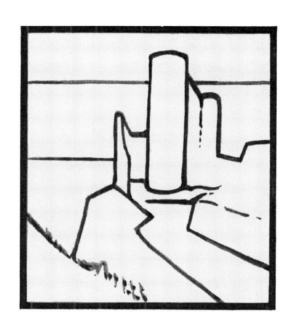

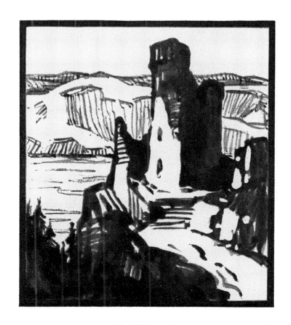

PLATE XIX 53

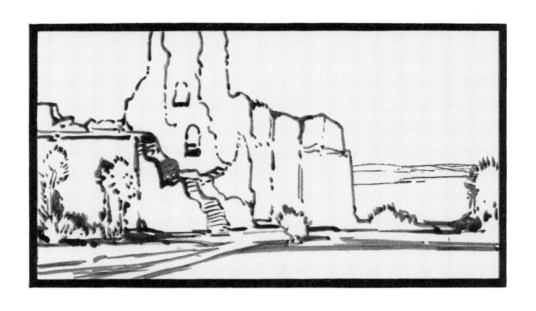

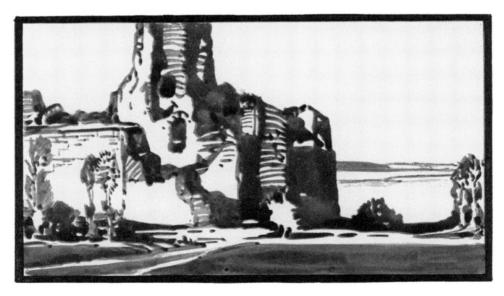

PLATE XX

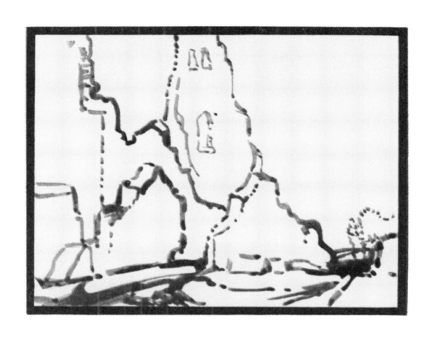

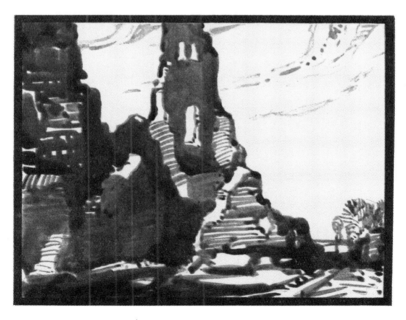

PLATE XXI

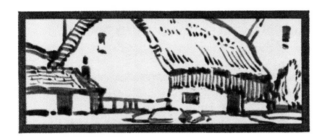 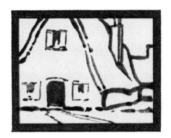

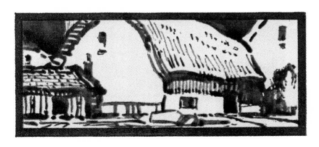

PLATE XXII

break up the flat surface of a wall and assume too much prominence.

On the other hand, open or closed doorways—when depicted with dark colours—add artistic interest to the subject, and also act as a link between the ground and the adjoining walls.

CHAPTER VII

COAST SUBJECTS

IT is a fascinating pursuit to draw the structural formation of rocks or cliffs on the sea-shore. The artist blessed with an independent mind is under no necessity to copy slavishly the hundred and one insignificant details attached to this type of subject, but the bold significance of rock forms can readily be selected and emphasized—or subdued—to suit the mood of the painter.

The diagrammatic stages drawn on Plate XXIII explain the constructional arrangement of the two subjects below.

Plate XXIV shows two first-class subjects, both worth treating for oil painting. The dark shadow masses on the contours of the cave on the right help to give an illusion of sunlight to the more distant scenery. The small figures on the shore enhance the general scale of the picture.

The top examples on Plate XXV were drawn with simple severity and show the contrast in the finished drawing, between the angular lines of the rocks, with the more sweetly curved road on the left.

The large composition in the centre is a bold treatment of jagged rocks and moving clouds, whilst the small picture at the foot of the plate is designed for the purpose of getting a decorative effect, which is further enhanced by the dark-toned cliff in the foreground, contrasting with the lighter-toned cliffs in the distance.

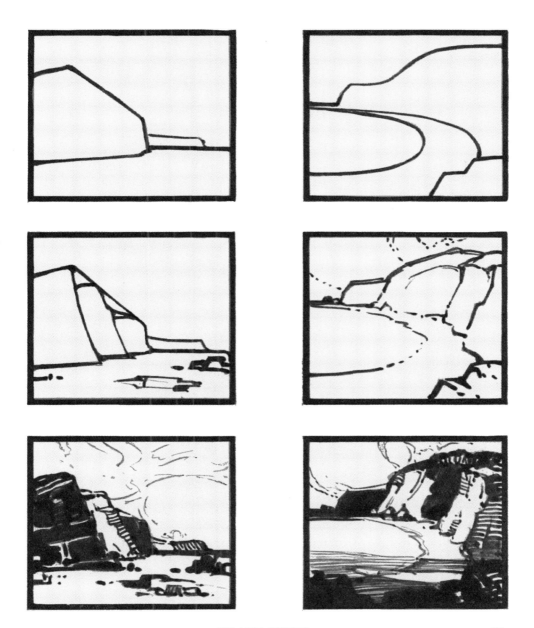

PLATE XXIII

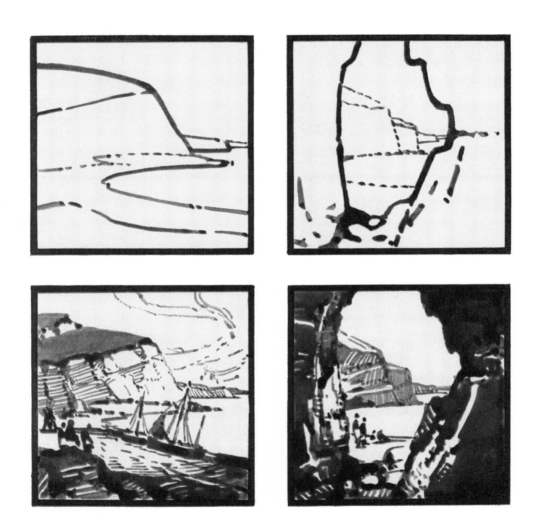

PLATE XXIV

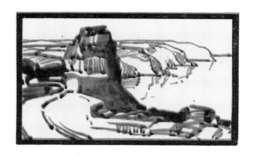

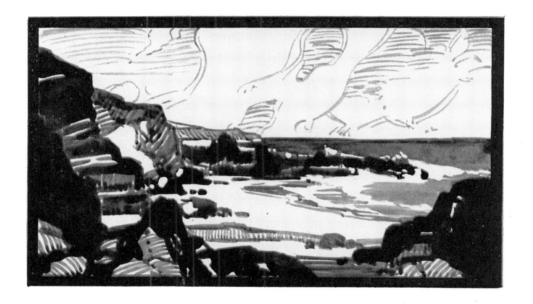

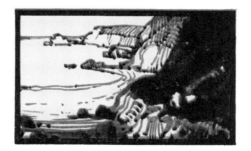

PLATE XXV

61

CHAPTER VIII

ROAD SCENES AND TREES

HOWEVER quickly or roughly an out-door sketch may be done of a tree—or a group of trees—the result should show the imprint of knowledge. Bearing this thought in mind, several diagrams and drawings are included in this chapter, so as to avoid obvious pitfalls.

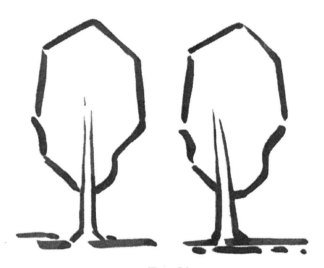

FIG. 24

Fig. 24 illustrates two simply-drawn trees. The first example on the left shows equal weight on each side of the centrally-placed trunk. The adjoining tree is not so good in construction, since the weight is not correctly balanced on either side of the trunk, i.e. showing too little on the left and too much weight on the right. The same remarks are applicable to the

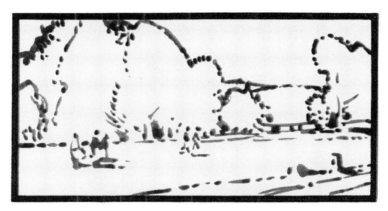

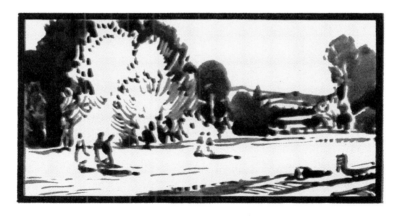

PLATE XXVI 63

two demonstrations in Fig. 25, as well as the examples in Fig. 26.

The two drawings in Fig. 27 depict a somewhat loose and

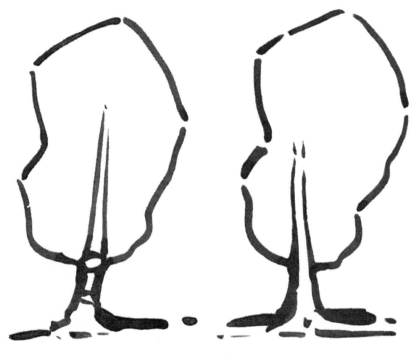

FIG. 25

naturalistic handling. So as to gain variety some shadow treatment was adopted in the example on the right.

The first illustration in Fig. 28 consists of a series of angular lines suggesting the contours of a tree. The adjoining drawing depicts the uneven edges of leaves, whilst still retaining the same angular foundation so noticeable in the first illustration. The other brush-work drawings below, are all based on the

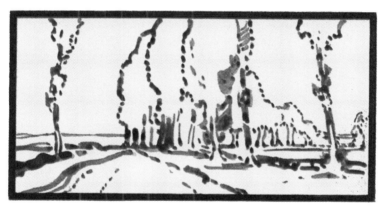

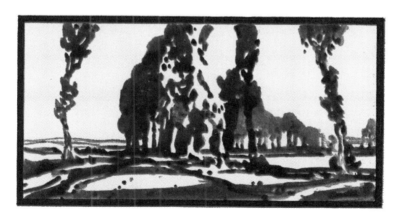

PLATE XXVII 65

principle of radiation, or a series of miniature curves springing from a given point.

This method of handling is noticeable in a modified form in

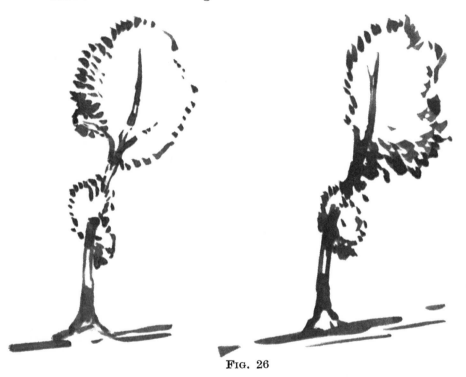

Fig. 26

the tall trees on Plates X and XXVI, but it should be practised apart from tree studies until the necessary mastery is gained.

The line-work in the different stages on Plates XXVI, XXVII, XXVIII, and XXIX indicate the constructional growth of a landscape. The sunlit trees seen in the finished picture on the first-mentioned plate become more noticeable

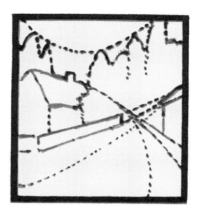

PLATE XXVIII

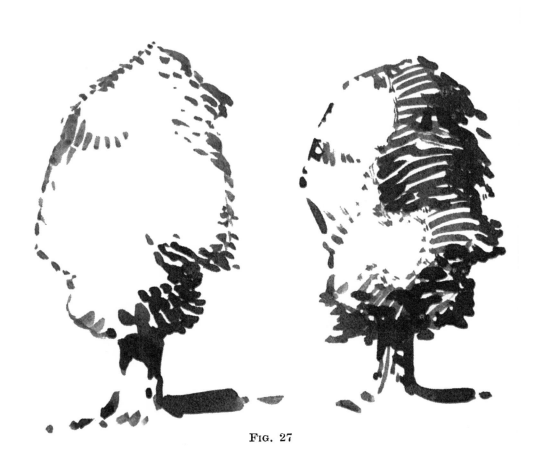

FIG. 27

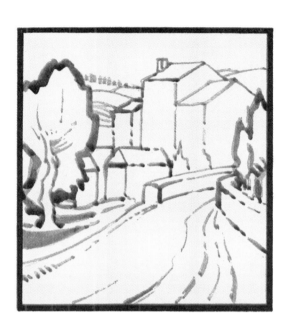

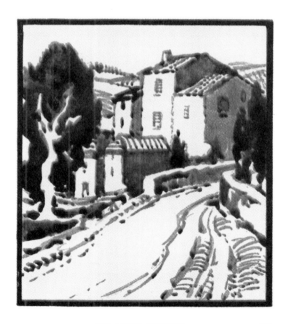

PLATE XXIX 69

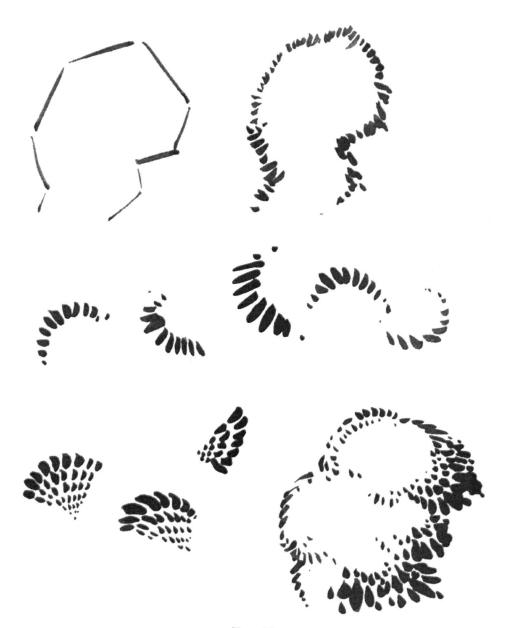

FIG. 28

through the intensity of the dark masses behind. The sweep-
ing horizontal lines of light and shadow on Plate **XXVII** help
to accentuate the height of the trees and to give stability to
the general design. The underlying compositions on Plate
XXVIII are not so easy to fathom as some of the previous
examples, but enough is shown to explain how each subject
is woven together by constructional lines and curves, enclos-
ing the main features. The road depicted in Plate **XXIX**
leads the eye into the picture, thus considerably helping to
add interest to the composition.

CHAPTER IX

RIVERS

IN pictorial subjects, water is generally easier to express in colour than a monotone medium such as sepia, or black and white, but, whatever medium is used, simplicity of handling is essential, particularly if the artist has had little experience in depicting water subjects.

Clear reflections are a blessing to the average artist, since the problem is infinitely easier when the subject-matter above is duplicated on the surface of the water below.

Quick-running water, carrying along varying staccato touches of reflected colour, and involving many surface intricacies, is liable to bewilder the mind of the spectator. It is, therefore, important to draw and paint with decision, plus simplicity. Additional knowledge in a picture can be added as experience grows.

The final drawing on the left side in Plate **XXX** shows the elimination of detail in the water situated in the foreground. A few reflections only are suggested such as the church tower and adjoining trees. The river scene in the other finished picture on the same plate, offered little difficulty in handling as the reflections were more obvious, or more like the trees, etc., depicted in the landscape, above the water line. It should be noticed that in both of these river subjects a few light sinuous curves are drawn on the water, so as to get a feeling of movement.

Similar curves are also shown on the water below the bridge with three arches, on Plate **XXXI**. The adjoining picture is free from disturbing curves, thus proving that the water is

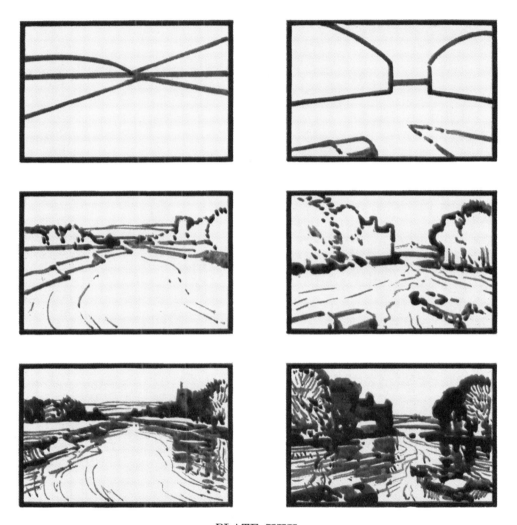

PLATE XXX

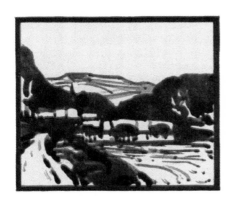
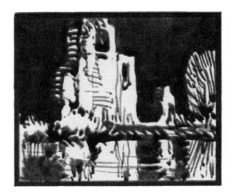

PLATE XXXI

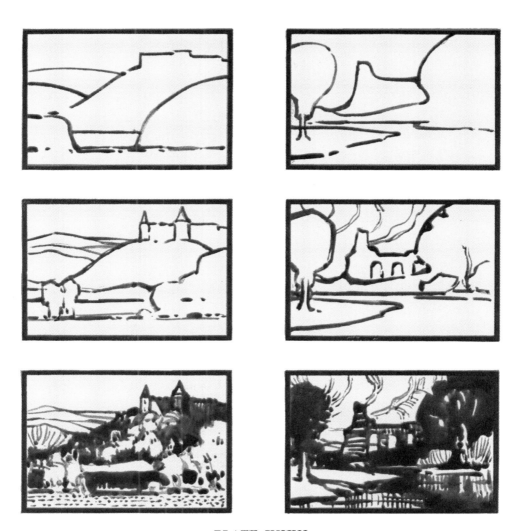

PLATE XXXII

almost stationary, with a corresponding increase in the clearness of its reflections.

Colour would help to emphasize the position of the horizontally placed river in the finished sketch on the left side of Plate **XXXII,** since the tall trees in the foreground partly obscure its existence. The other picture on the right denotes that the river water is tranquil as the reflections are similar to the tone and shape of the trees and ancient ruin above.

CHAPTER X

BRIDGES

THE introduction of the simplest form of architecture amongst natural landscape surroundings gives an added zest to the subject. The great rocks and crags piled up on parts of Dartmoor help all the other aspects of nature in the adjoining vicinity, not because they can be classed as architecture, but because they suggest a similar atmosphere.

Bridges—ancient or modern—are of necessity architecturally planned; in other words, a geometric arrangement is involved in their construction such as semi-circular arches, supported on either side with upright buttresses, whilst the whole structure is arranged on a symmetrical basis.

The contrast between the efficient solidity of organized masonry which remains strong under the pressure of wind and water, as compared to the nervous movement of grass, leaves, fleeting clouds, etc., is probably one of several reasons why a bridge is capable of bringing so much interest to a pictorial landscape. It also stimulates a sense of adventure, since one can pass over a river or road and is thus lead from one territory to another.

For the purpose of pictorial design a bridge, or viaduct, plays an important part in the composition, and is often a connecting link by joining one part of a landscape to another. This is very noticeable in the two pictures on Plate XXXIII. In each instance the bridge is indispensable to the subject.

The bridge in Plate XXXIV is important as it occupies a good deal of room in the foreground, and also spans across the picture. The shadows on the left side and underneath

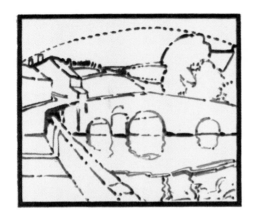 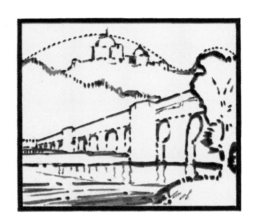

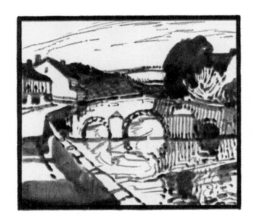 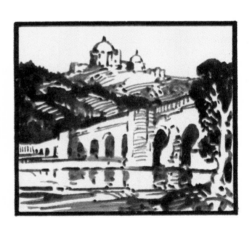

PLATE XXXIII

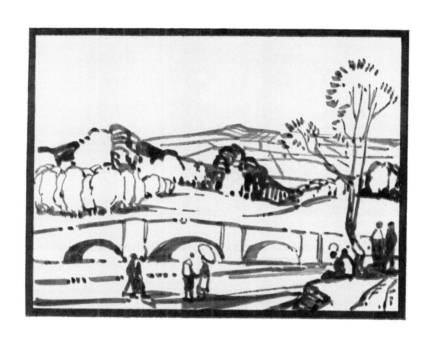

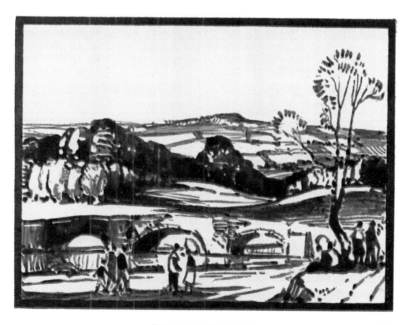

PLATE XXXIV 79

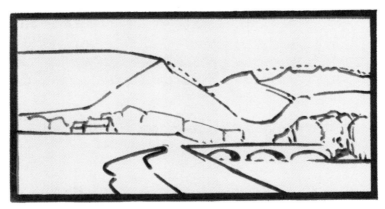

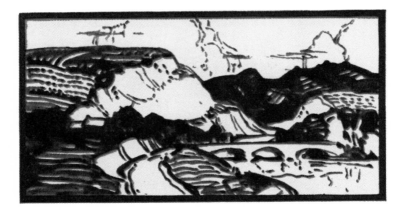

PLATE XXXV

the arches are necessary, so as to support the groups of dark
trees spreading along the middle distance. Contrast is shown
by various figures in the foreground, and the delicately
formed tree on the right cutting across the horizontal lines
in the landscape.

Although the bridge in Plate **XXXV** appears small in rela-
tion to the surroundings, it is really an important feature,
since so many compositional lines in the landscape lead the
eye that way.

CHAPTER XI

HILLS AND MOUNTAINS

THERE is plenty of scope for decoration in the planning of hills in a pictorial design. The type that is partly covered with forests and bracken, or displaying an arrangement of intersecting fields of various colours, add considerable charm to the subject, especially if the valleys are in deep shadow, as this helps to enhance the value of the heights above. The appearance of cottages in hilly landscapes assist in giving colour contrasts to the adjoining material such as trees, fields, roads, etc.

Plate XXXVI shows two hill pictures each of which is developed in three stages. The principle of intersecting lines and curves shown in Figs. 5 and 6 as well as Plates I and II are easily recognizable in the various stages connected with the construction of these two subjects. Some weight and significance was gained in the finished drawings by the addition of dark masses, thus differentiating the various items contained in the respective subjects.

The mountain subjects illustrated on Plates XXXVII and XXXVIII were made from the Canadian Rockies. The first-mentioned plate lends itself easily to decorative treatment. When snow is lighter than the sky in a picture it generally portrays interesting patterns. The same remarks apply to snow in shadow, except that it is less assertive and more difficult to decipher. In any event the delicate beauty of snow enhances the strength and colour of mountain rocks.

The great pine trees and lakes of Canada are all amenable to pictorial designing. There is room for personal expression— or invention—with such majestic material.

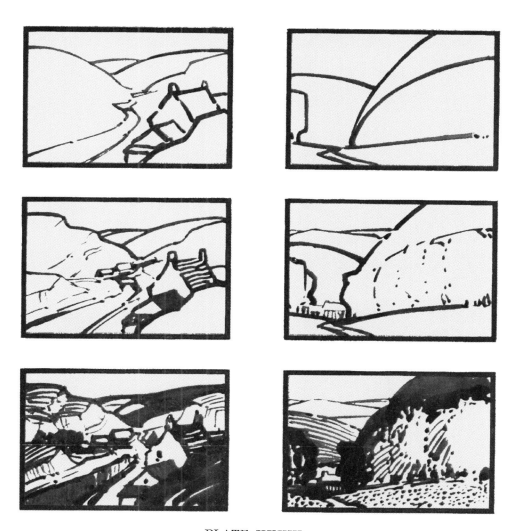

PLATE XXXVI

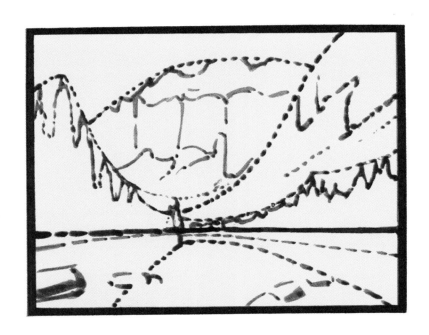

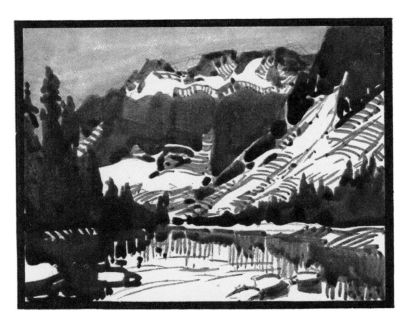

PLATE XXXVII

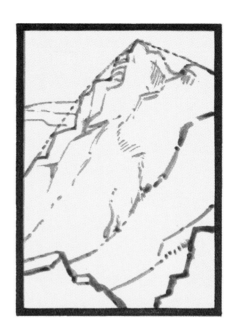
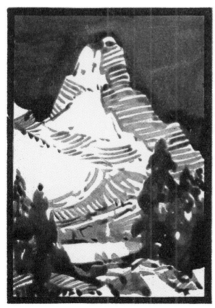
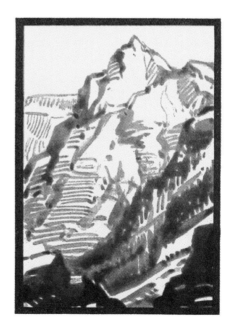

PLATE XXXVIII

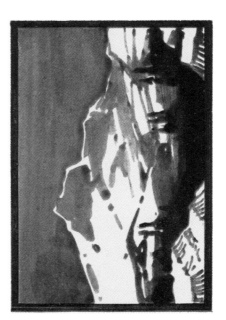

PLATE XXXIX

The upright panels on Plate **XXXVIII** are easily filled with towering mountain subjects, since the panel itself tends to help the illusion of height. It is, therefore, a problem that offers little difficulty, but care must be taken that the apex of a mountain—being so noticeable—should be placed either a little to the right or the left side of the panel. If put in the centre it is liable to produce a monotonous composition. Each of the two finished panels shows some dark-toned material at the foot of the picture, so as to support the higher portion of the design.

In Plate **XXXIX** the mountain subject on the right is based on a more original composition than some of the other examples. The dark group of trees at the base of the adjoining picture gives value to the tone of the sky and snow above.

CHAPTER XII

PLATE XL displays a decoration based on a hilly landscape and designed so as to fit an upright panel. The first drawing on the top left side shows the main elements of the composition. In the finished example immediately below, the trees are not modelled so much as the larger picture on the right, since they are painted with a more or less flat surface. The hilly distance is also rendered more with wash drawing, instead of the line treatment shown in the adjoining subject. In the larger landscape the distant trees on the left are better drawn and more luminous than the small example.

This style of decoration is appropriate for a book cover jacket design. There are also certain elements in it which, in colour, would make it appropriate for a poster.

The four line drawings on Plates XLI and XLII are an innovation for this book, as each were done with a pen and brown ink instead of a small paint brush, as shown in all the other reproductions. The pen drawings in the first-mentioned plate owe their origin to the two examples depicted on Plate IX. It is interesting to compare the difference between the wash drawings and the pen drawings. For the latter treatment more detail should be included, otherwise there is a danger of the drawing looking empty and meaningless. The bolder handling of a brush necessitates a different technique in pictorial draughtsmanship. Similar pen treatment is displayed in the two drawings on Plate XLII. They were designed from the arbitrary setting shown on the top line.

The two wash drawings on Plate XLIII were also evolved from a pre-arranged setting as shown above.

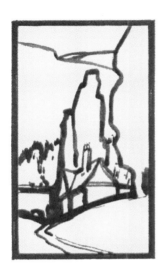

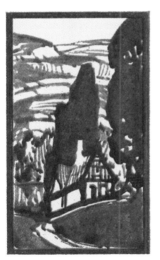

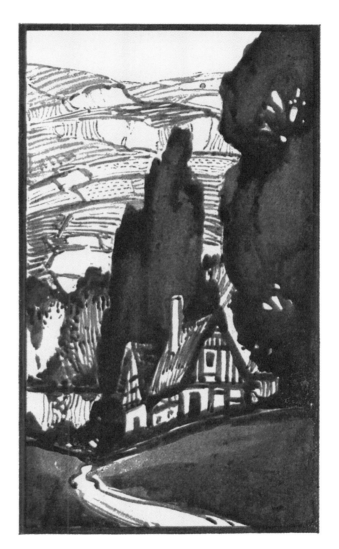

PLATE XL

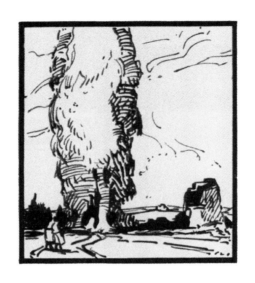

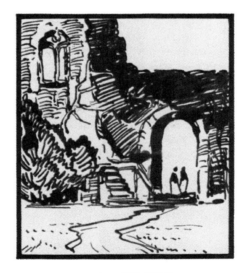

PLATE XLI

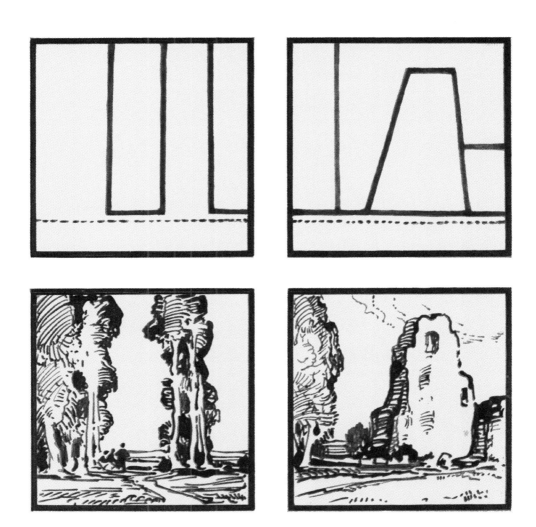

PLATE XLII

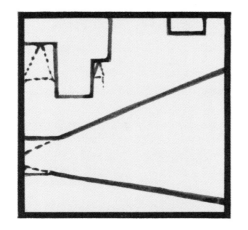

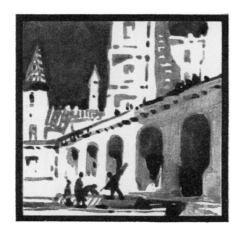
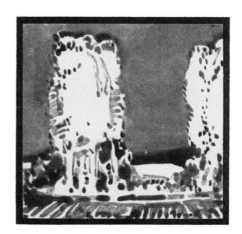

PLATE XLIII

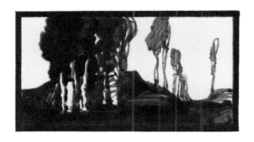

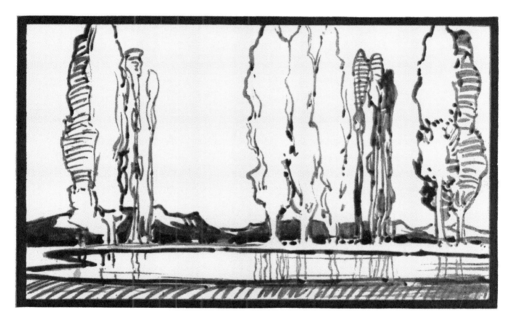

PLATE XLIV 93

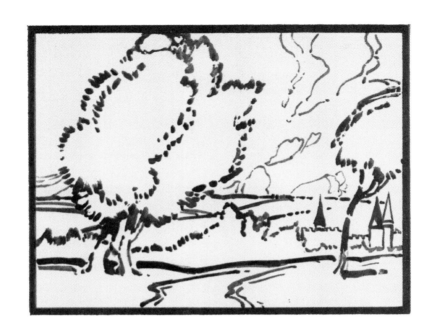

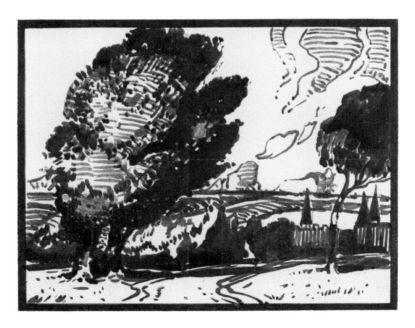

PLATE XLV

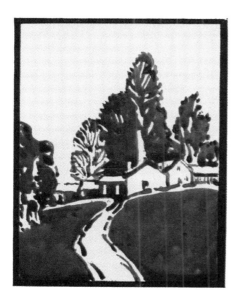 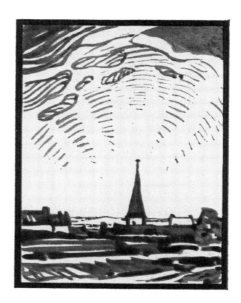

PLATE XLVI

95

All the wash drawings on Plate XLIV are imaginative sketches designed to fill the five rectangular panels. Trees are the predominating factor in each subject, and they were drawn without any responsibility as to their origin in nature. Although the trees in the central panel might be taken for poplars, it must be clearly understood that the artist had no studied intention of depicting them as such.

It is excellent practice to design compositions in the studio without allowing nature to impose any limitations on the subjects. Freedom in thought is essential for original conceptions. A good landscape or figure composition which has originated from the mind of the artist, is sometimes much improved by the introduction of detailed drawings made direct from nature or life, but the conception of the subject tells the story, whilst nature adds the trimmings.

The sensation of movement in a landscape becomes very noticeable when the different elements (excepting buildings and other solid items) within the subject conform to the direction of the wind. The trees and clouds both slope from left to right in Plate XLV, thus helping to give the illusion of movement caused by wind.

On Plate XLVI the outline drawing on the top left side indicates the position of the compositional masses below. The receding pathway across the foreground meadow leads the eye to the more interesting parts of the landscape.

The two pictures on the right should prove of some interest, since the radiation of light spreading diagonally across the sky, the drawing of the foreground, and the spacing of the various shadows show the result of two interpretations of the same subject.

CHAPTER XIII

L ARGE numbers of people visit well-known art galleries in different countries. In England alone many thousands flock each week to view examples of pictorial art.

Possibly curiosity has something to do with the desire to look at paintings, or it may be some go because it is the right thing to do. In any case, it is extremely doubtful whether ten per cent of the audience have an enlightened appreciation as to how the component parts of a picture are fitted together, so as to make an interesting pattern. Pattern, of course, not only includes the planning of masses and co-ordinating lines, but colour also is involved in the general spacing of a picture. This book, however, is not concerned with colour—although a fascinating subject—since there is so much to learn in pictorial design before attempting other problems.

"The Wind on the Wold," by George Heming Mason, A.R.A., on Plate XLVII, shows an unusual composition. The general direction of somewhat parallel lines and curves, sloping downwards from the right towards the left side of the picture, is indicated more clearly in the line drawing below. The feeling of movement is well expressed, more especially through the pose of the girl carrying the sloping stick, and the arrangement of the bare branches immediately behind her. The spacing of the calves and trees also helps to convey a wind-swept scene.

Sir D. Y. Cameron's picture of "Stirling Castle," in Plate XLVIII, is an example of serenity in design. The building occupies a central position in the landscape with a steadying horizontal line below, extending across the picture. The

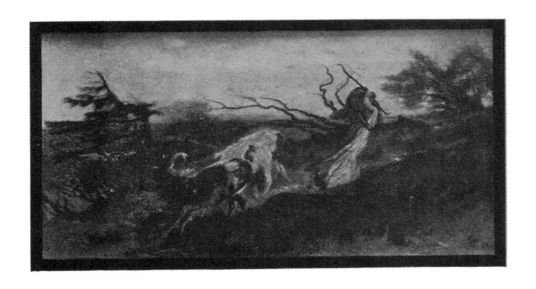

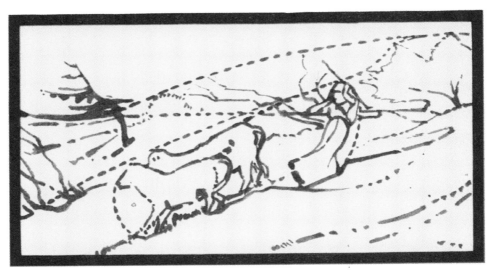

PLATE XLVII
THE WIND ON THE WOLD
George Heming Mason, A.R.A.

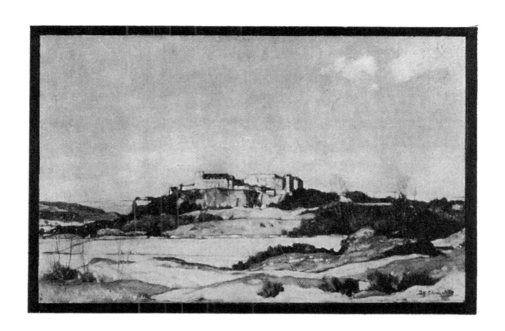

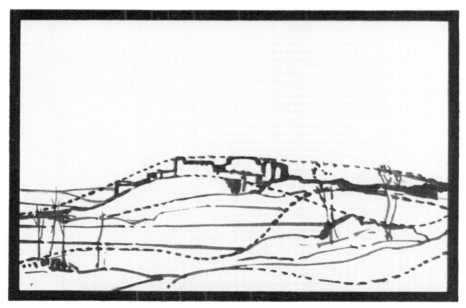

PLATE XLVIII

STIRLING CASTLE

Sir D. Y. Cameron, R.A.

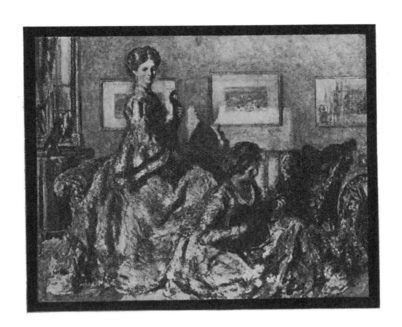

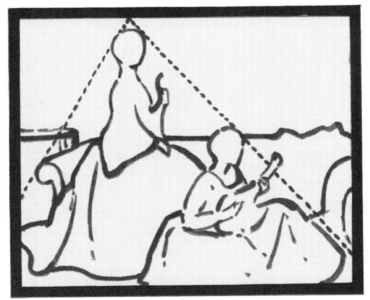

PLATE XLIX

THE MUSIC ROOM

P. Wilson Steer

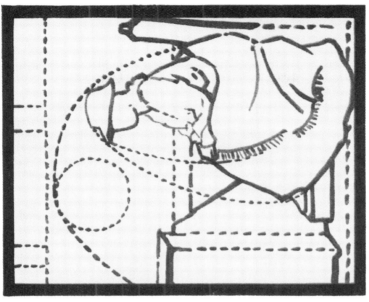

National Gallery, Millbank, London

PLATE L
THE MIRROR
Sir William Orpen, R.A.

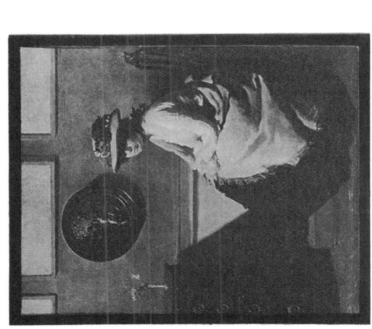

By courtesy of

foreground suggests charm and movement without disturbing the severer aspects of the distant castle.

P. Wilson Steer's painting, entitled "The Music Room," Plate XLIX, is well balanced by the crinoline-shaped dresses in each of the two figures. The triangular dotted lines in the explanatory drawing suggest the main setting of the subject, whilst the horizontal line of even-sized wall pictures behind add stability to the composition.

The late Sir William Orpen, R.A., displayed mastery in the planning of his picture entitled "The Mirror" on Plate L. Attention should be given to the various dotted curves spread elliptically around the contours of the dress and head shown in the analytical drawing. The angular wall pictures, like the setting in Wilson Steer's picture, helped to make an interesting pattern, as well as a contrast to the circular mirror and the soft folds of the dress.

The circular dotted curves seen in the diagram attached to the painting by John Sell Cotman entitled "The Drop Gate," Plate LI, explain the basis of an original composition—as unexpected as it is interesting. The clever massing of the group of dark trees in the background gives ample support to the lighter tone trees, and the other foreground subjects.

Plate LII, "Don Quixote," by Honoré Daumier, is a powerful composition which adroitly carries out the message of the artist. The pattern—or design—in this picture requires little explanation, consequently the task of making an analytical composition as depicted below was comparatively easy.

The sea-shore figure painting entitled "La Plage," by Degas, on Plate LIII, is an example of superb drawing. The reclining figure of the girl with sunshade is worth a good deal of serious study, especially in the general direction of the body and the partly hidden face. The arrangement of the dark foreground material suggests the influence of Japanese art.

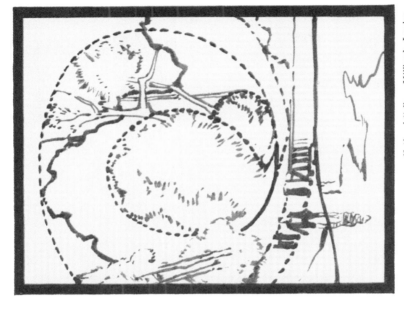

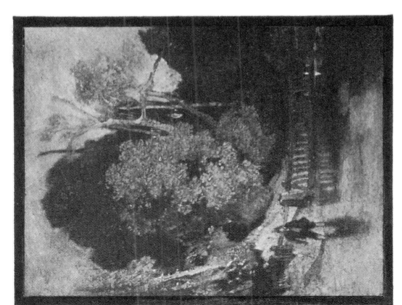

PLATE LI
THE DROP GATE
John Sell Cotman

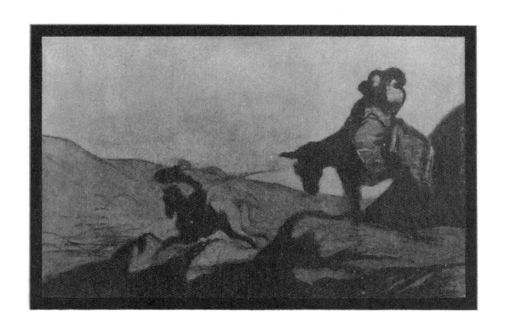

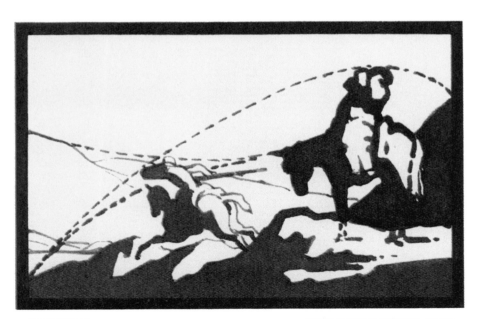

PLATE LII

DON QUIXOTE

Honoré Daumier

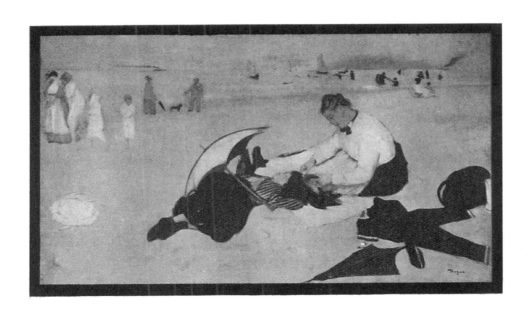

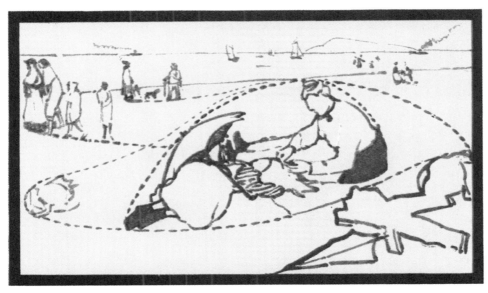

PLATE LIII
La Plage
Degas

105

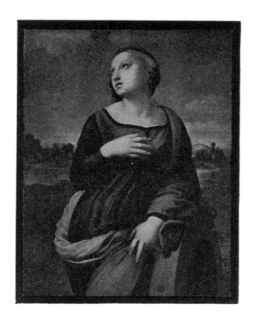
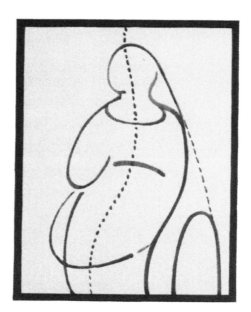
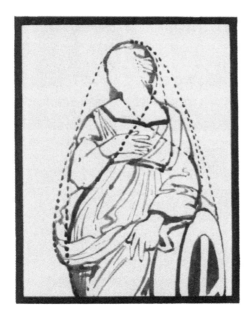
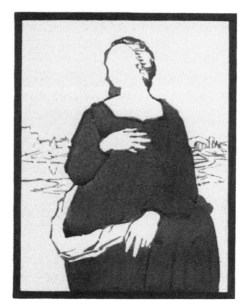

PLATE LIV
ST. CATHERINE OF ALEXANDRA
Raphael

The underlying compositions of Plate LIV up to Plate LVIII inclusive, have been explained as far as possible by three progressive analytical drawings for each subject.

The painting by Raphael entitled "St. Catherine of Alexandra," shown in Plate LIV, was chosen because it represents a pure example of harmonious lines. Apart from the decided curves seen in the sloping folds of the dress, consideration should also be given to the wheel at the foot of the picture, as it not only helps to support the figure, but its circular formation carries on the feeling of harmony. The light on the head and neck, the two hands, and the curved band of cloth on the left, are more clearly emphasized in the wash drawing at the foot of the plate.

The next picture, on Plate LV, entitled "Vision of a Knight," by Raphael, is precisely the opposite to the pleasant rhythmic lines of "St. Catherine of Alexandra." Here the harmonious feeling is replaced by a stern setting, yet none the less decorative. In the first stage the severe straight line composition is shown with simplicity. The second stage on the lower line depicts the way in which the compositional lines of the reclining figure of the knight lead upwards to the figure on the left. The third and final stage on the right includes a corresponding number of additional lines connecting together various units, so as to complete the whole pattern.

Plate LVI, entitled "Flora," by Palma (Vechio) should offer little difficulty to the seeker of the secrets of pictorial composition. The three progressive drawings give enough information without the aid of words.

The painting entitled "Christ and the Magdalene," by Titian, on Plate LVII, was purposely selected for analytical dissection because I could not, in the first instance, find out what sort of composition or pattern underlay the subject. The two figures compose excellently together, but the chief

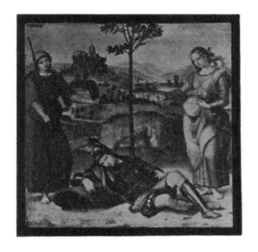

 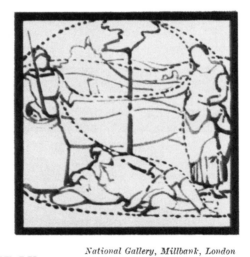

PLATE LV
VISION OF A KNIGHT
Raphael

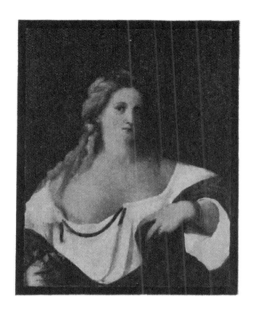

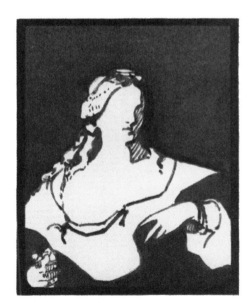

By courtesy of

National Gallery, Millbank, London

PLATE LVI
FLORA
Palma (Vechio)

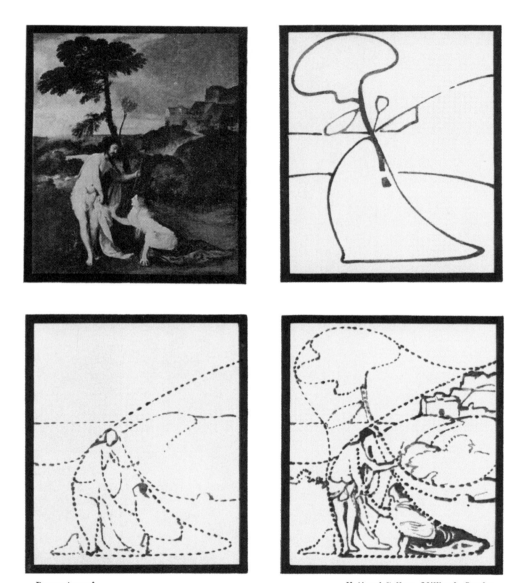

PLATE LVII

CHRIST AND THE MAGDALENE

Titian

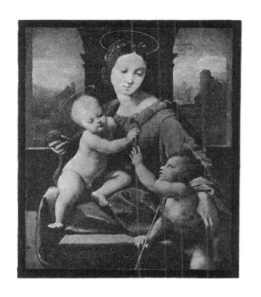
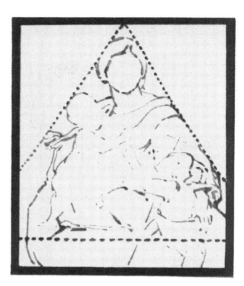
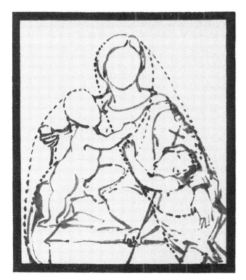
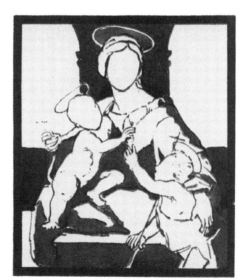

PLATE LVIII
MADONNA, CHILD, AND ST. JOHN
Raphael 111

difficulty lay in discovering in what manner they were related to the picture as a whole. The three stages, commencing from the first on the top line, demonstrate how I solved the puzzle.

The analytical drawings relating to the subject of Madonna, Child, and St. John, by Raphael, shown on Plate LVIII, serve to explain the progressive construction of this picture.